This

COLORING BOOK

BELONGS TO

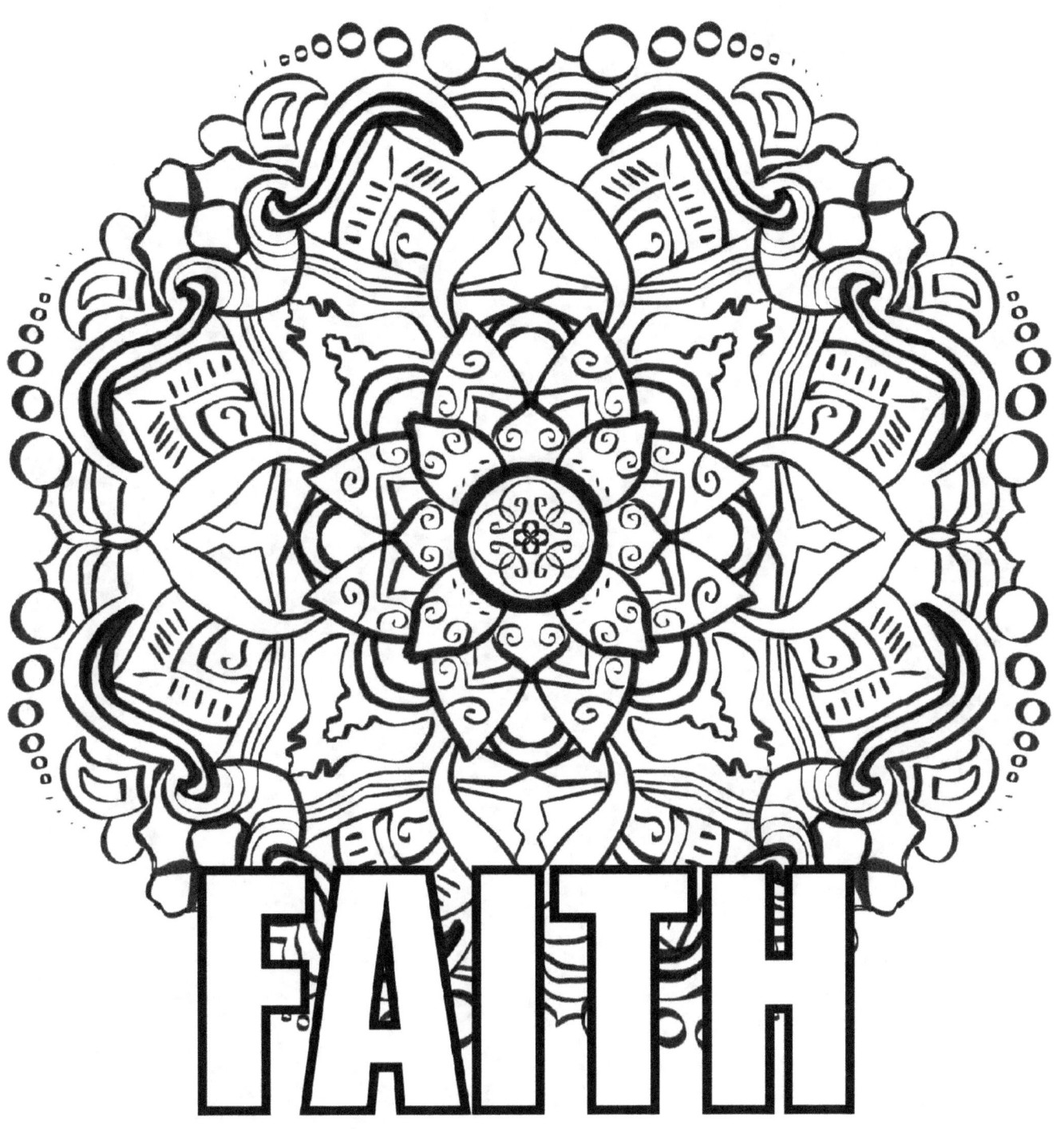

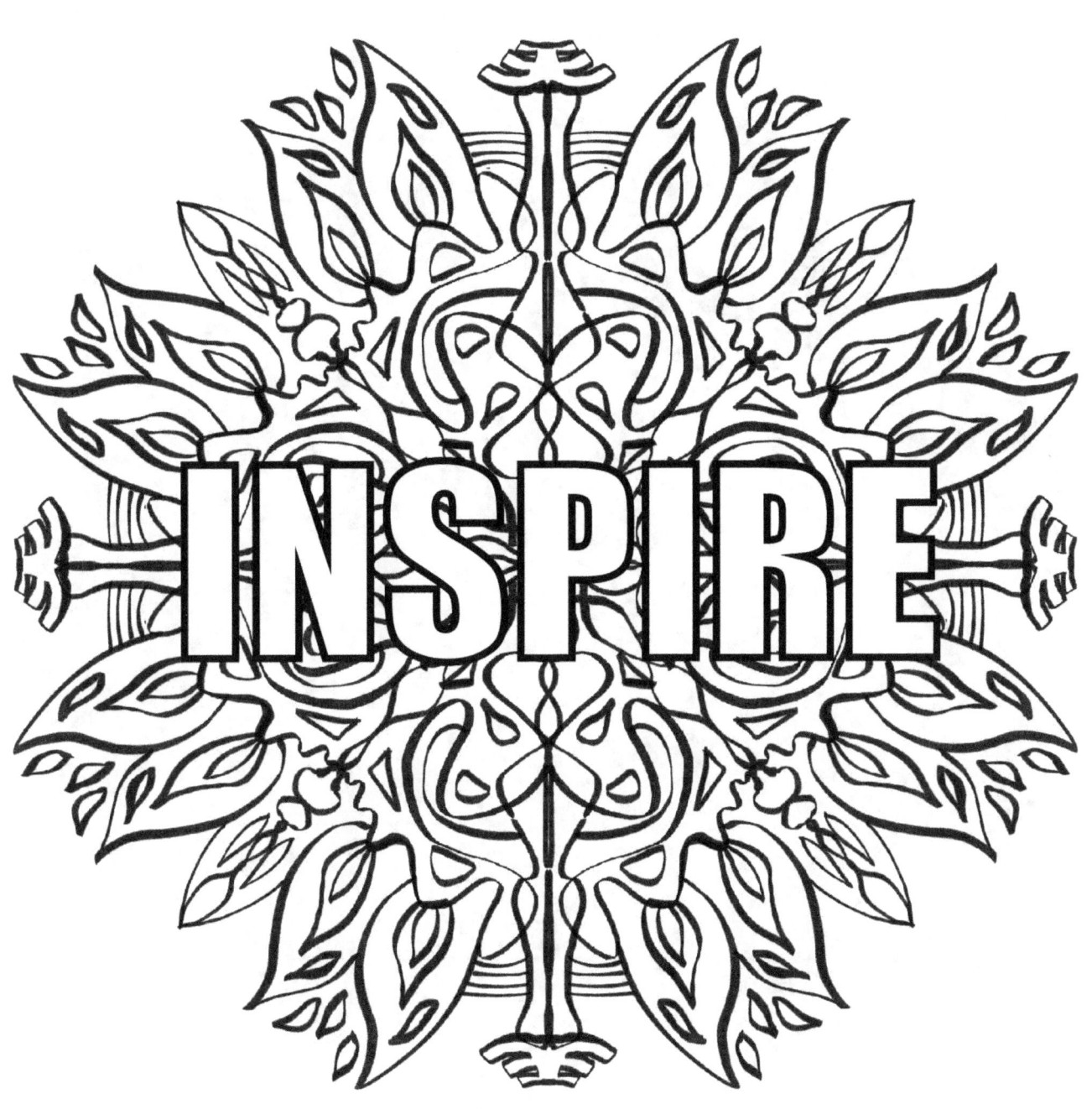

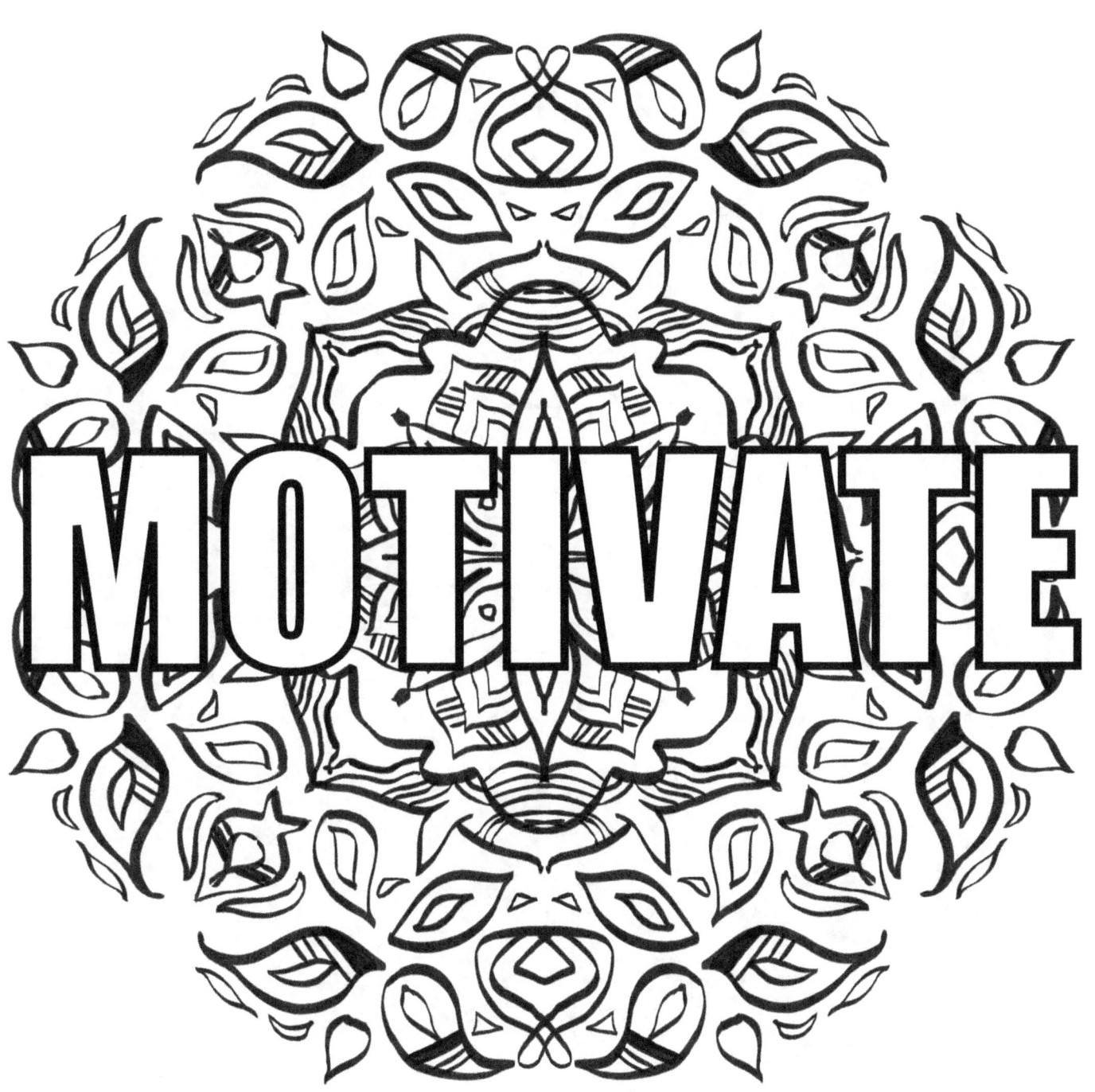

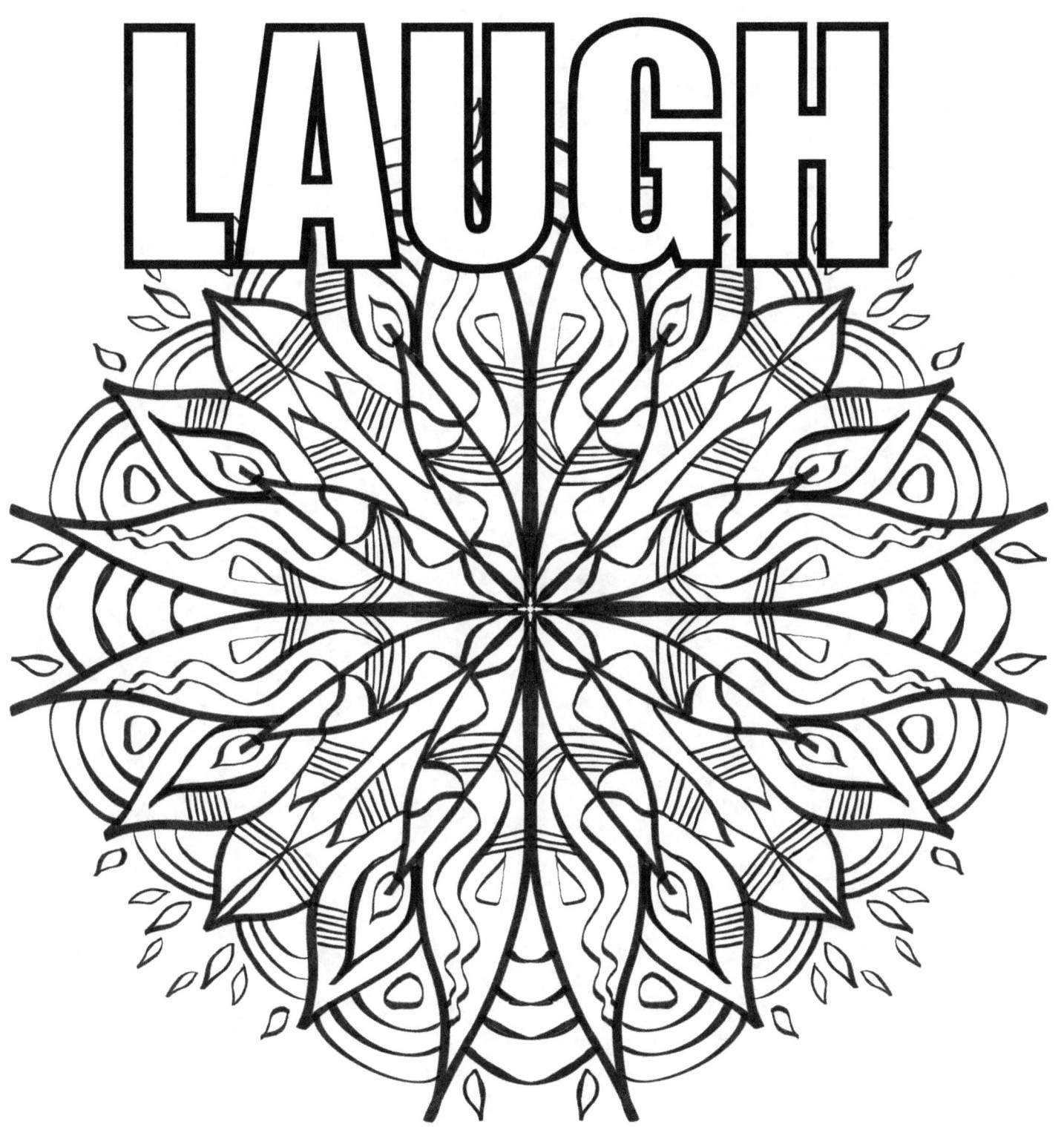

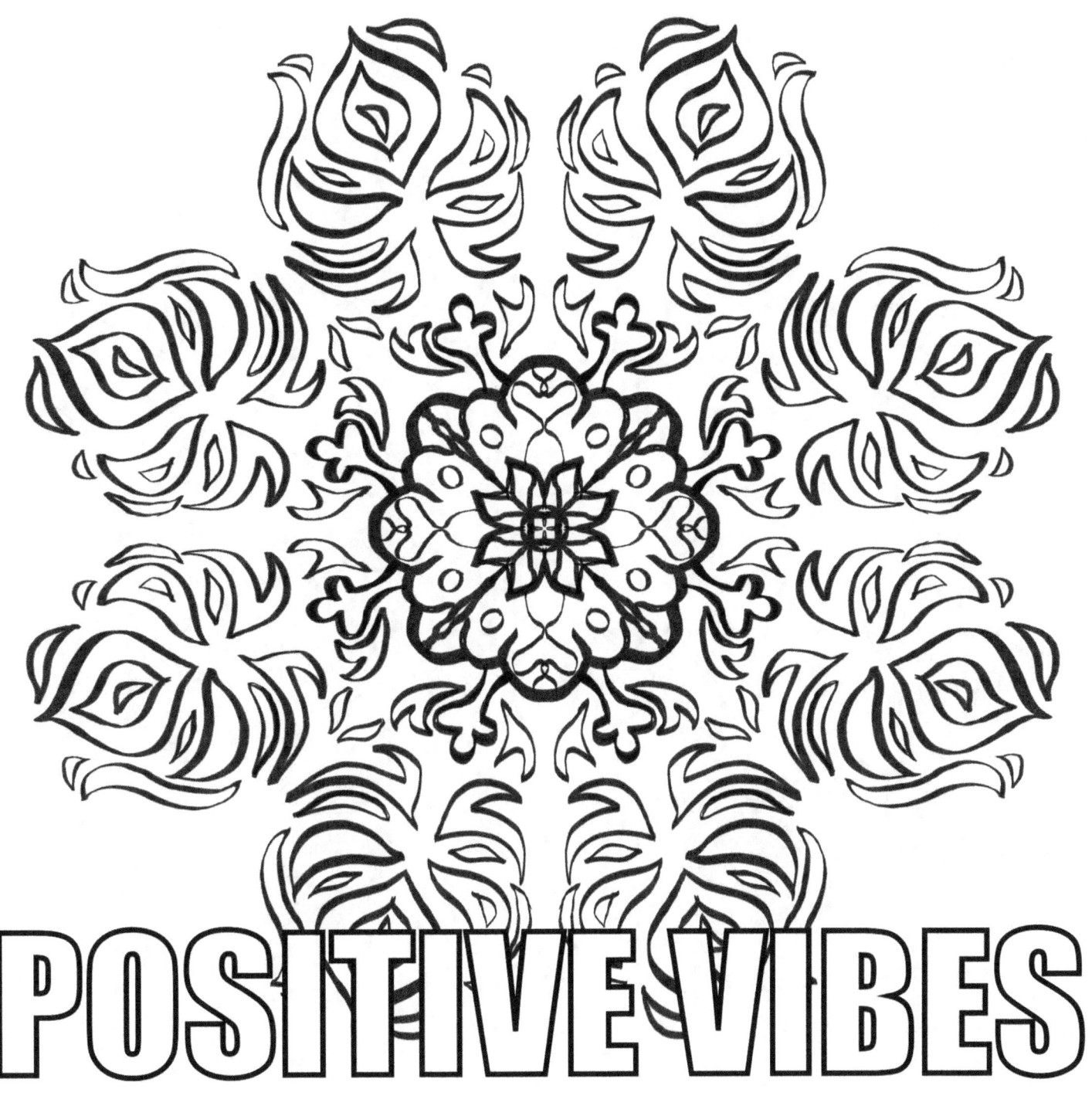

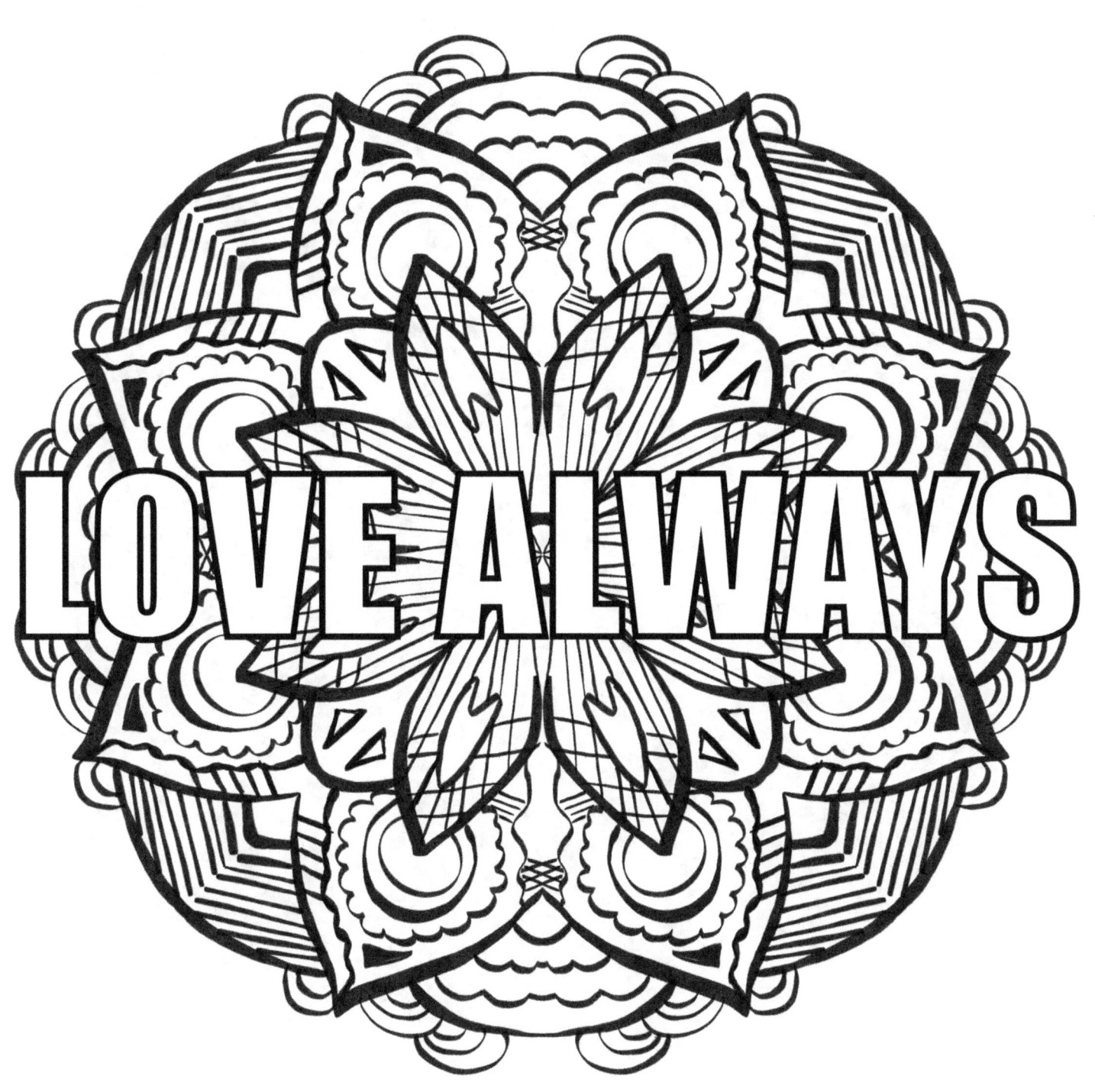

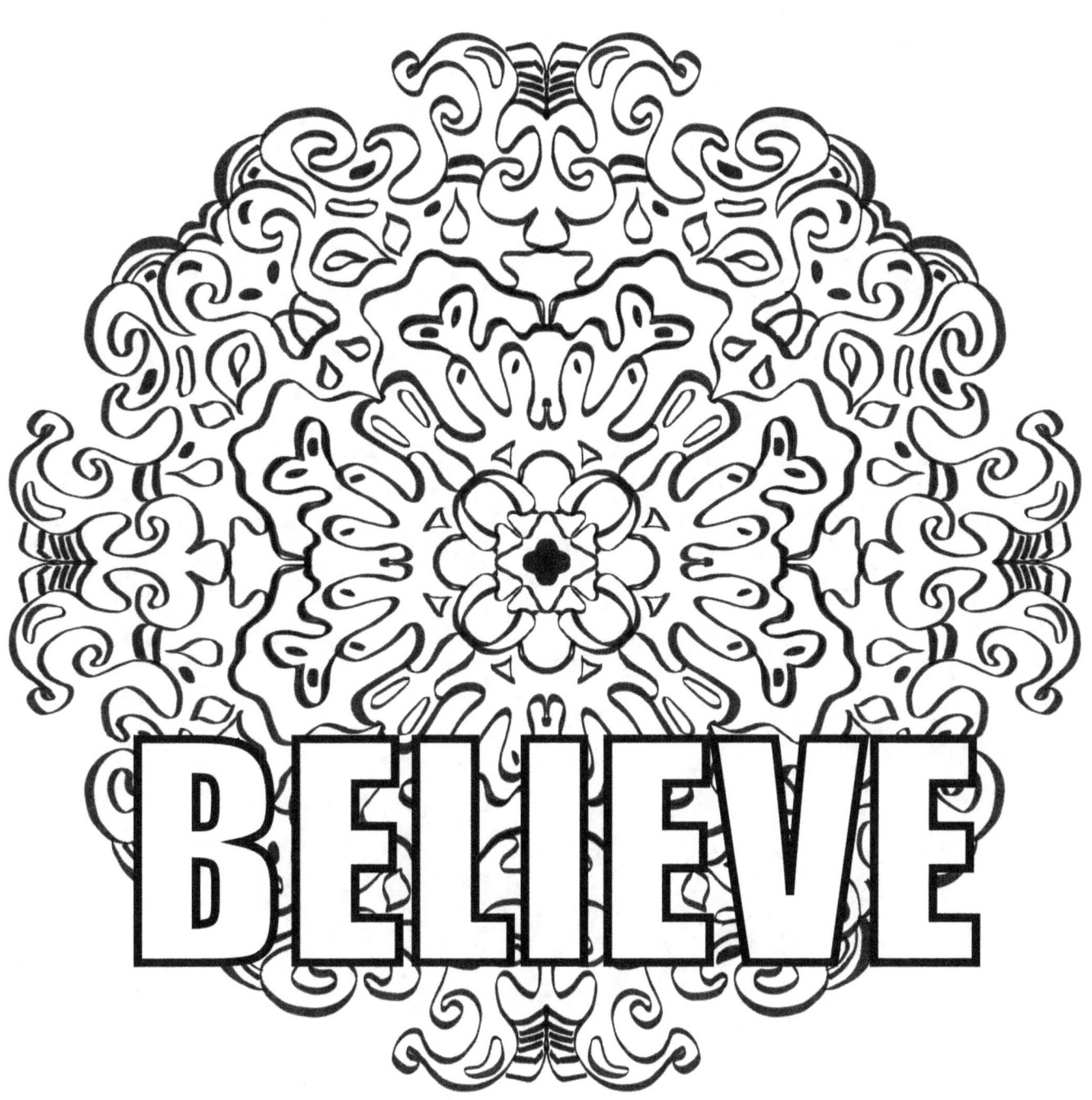

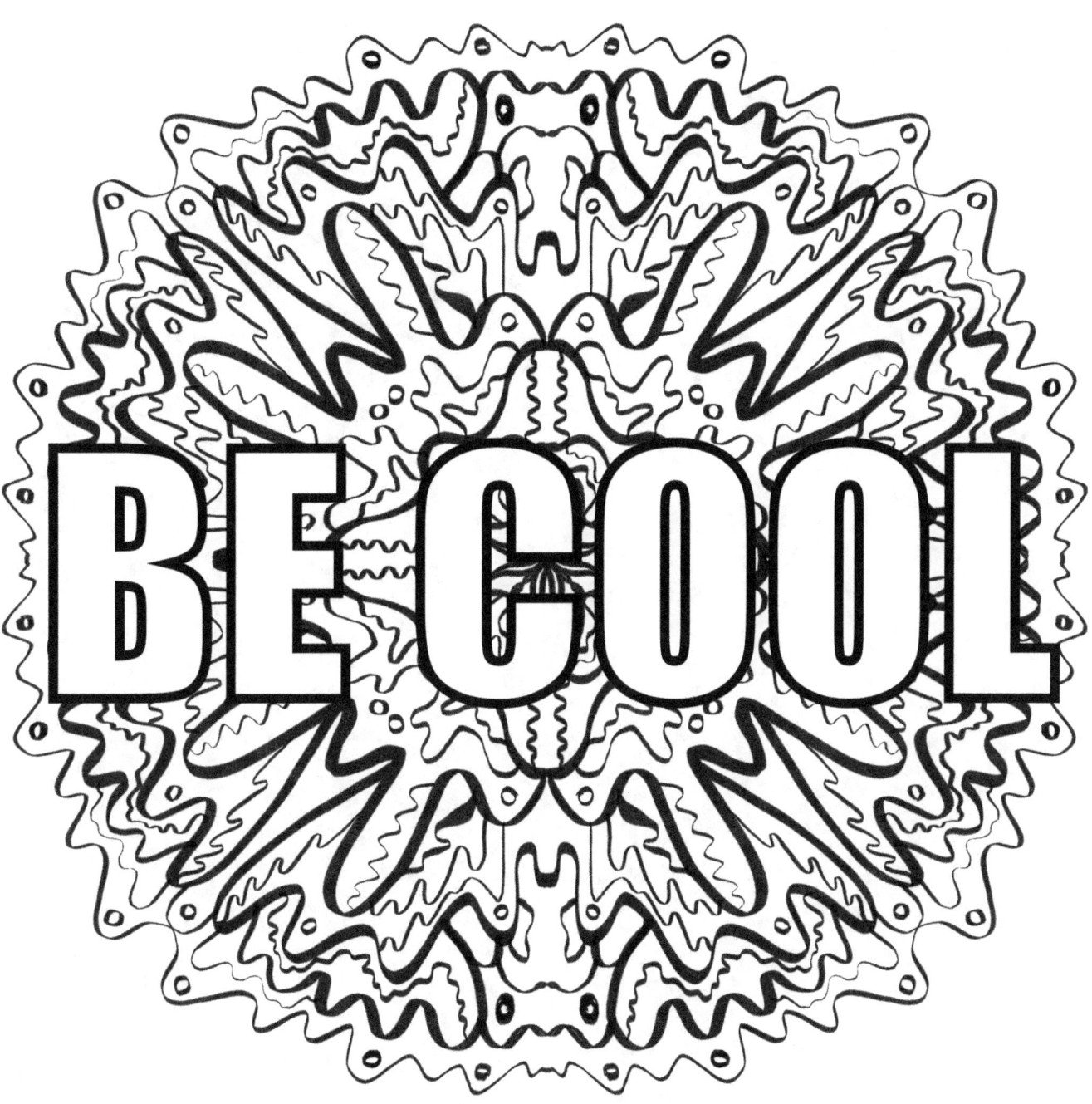

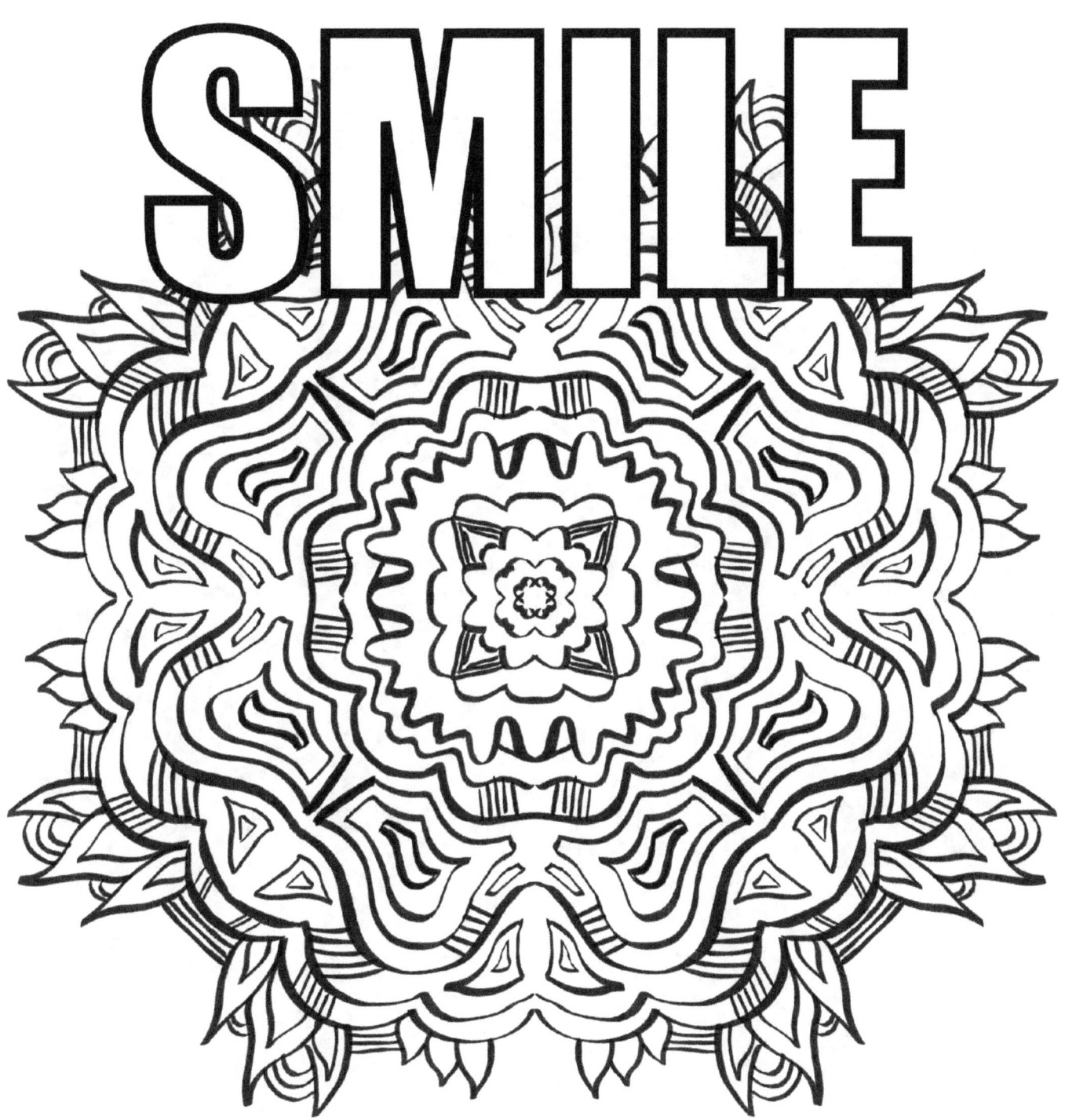

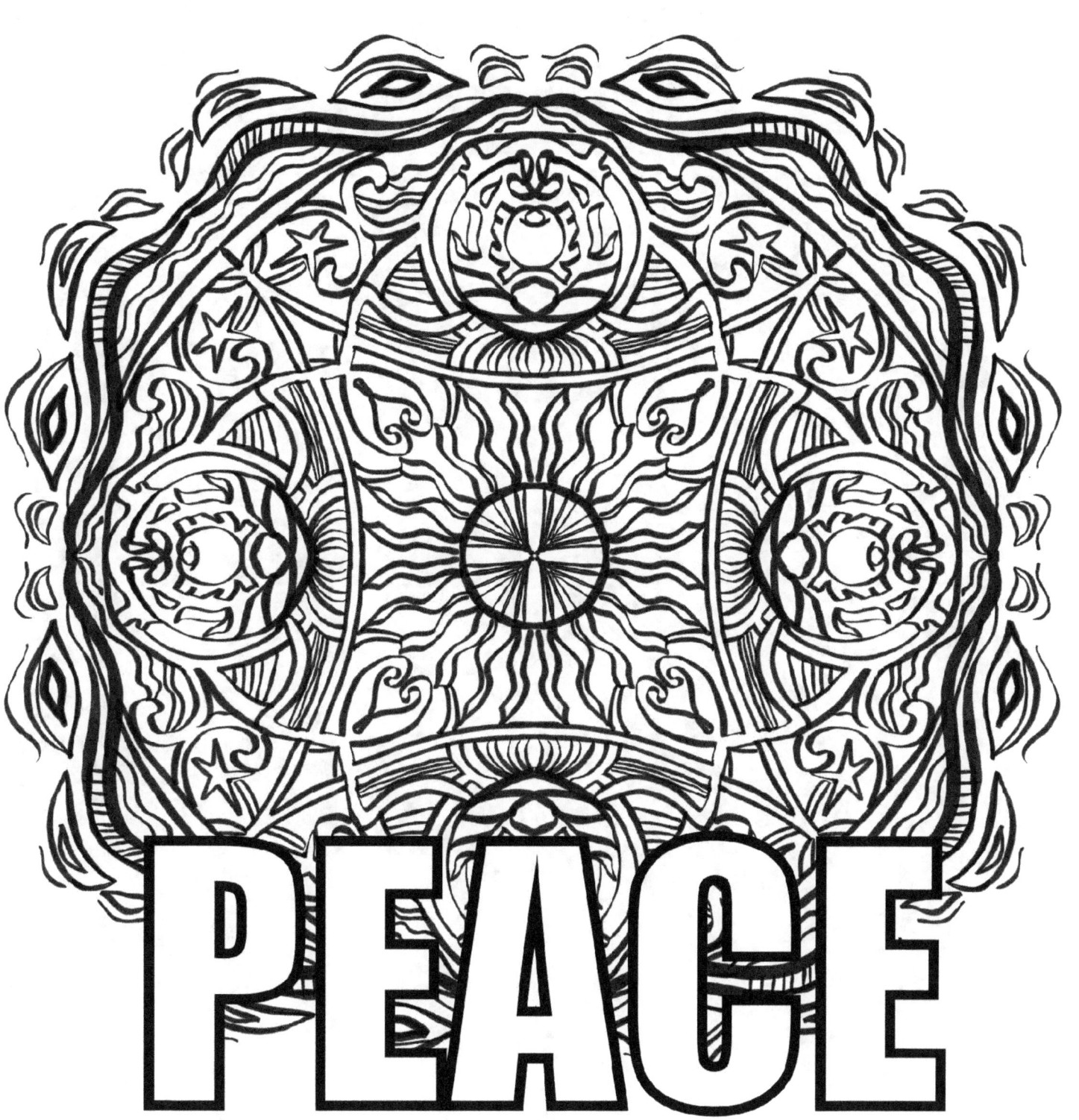

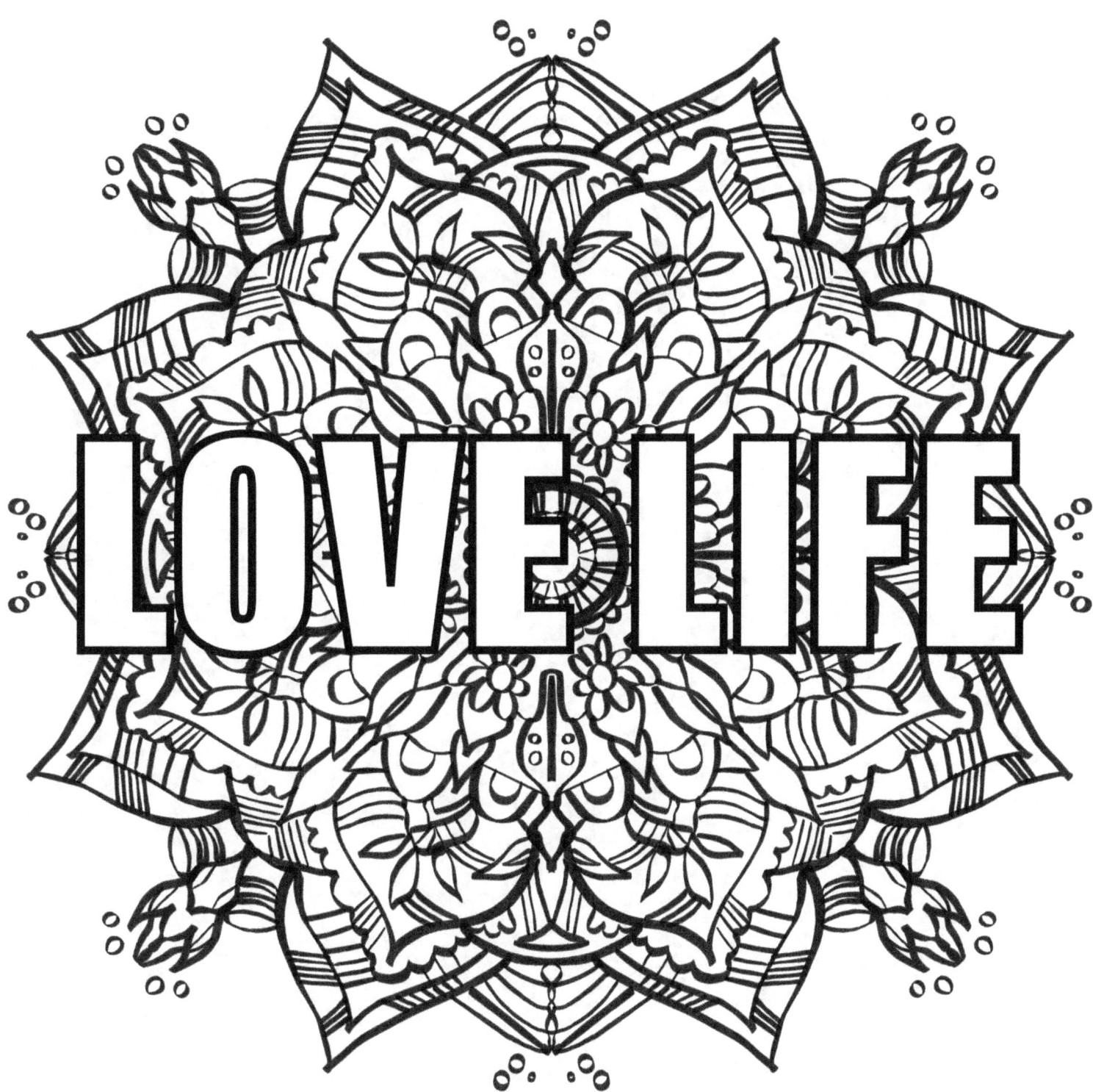

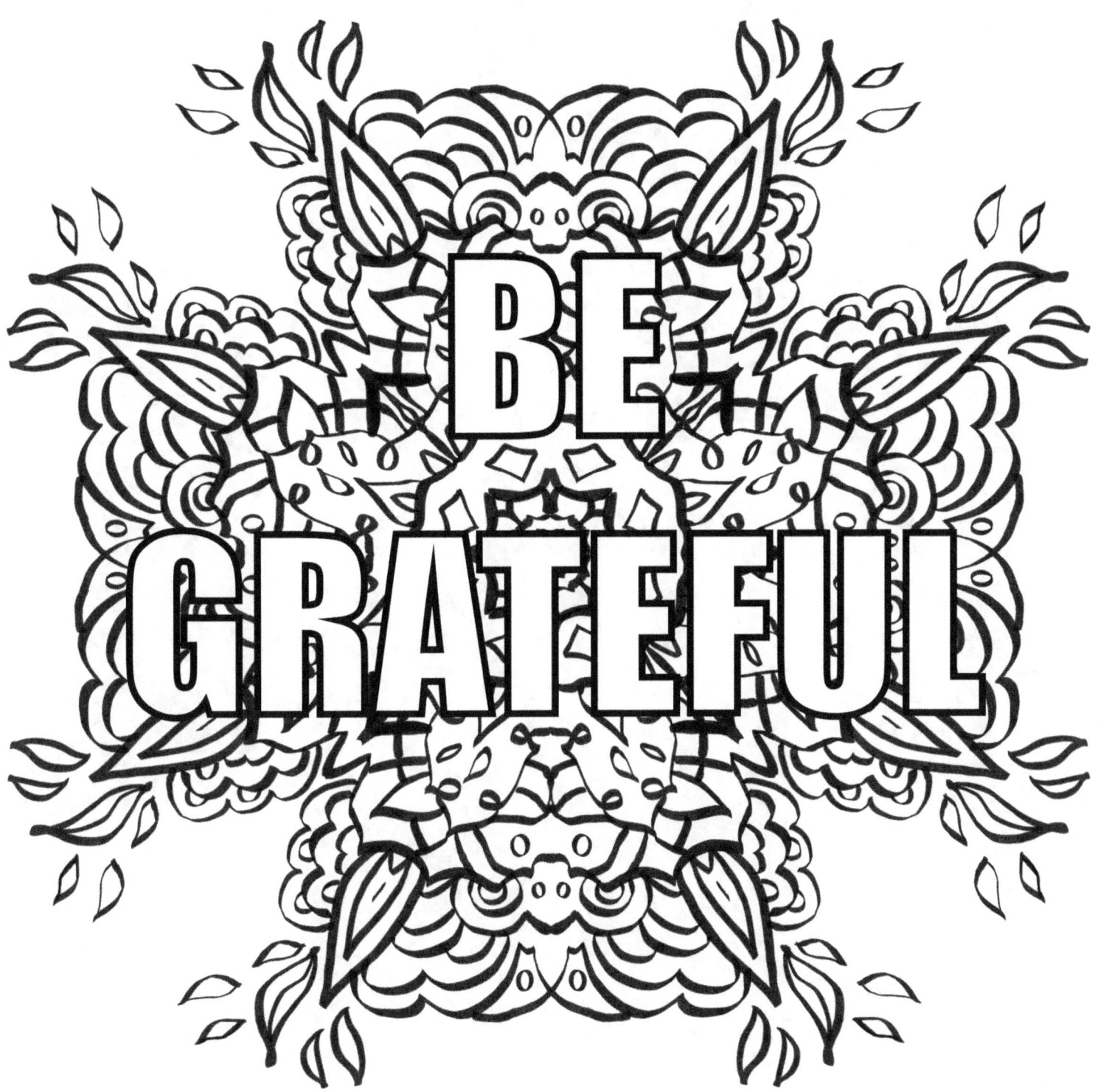

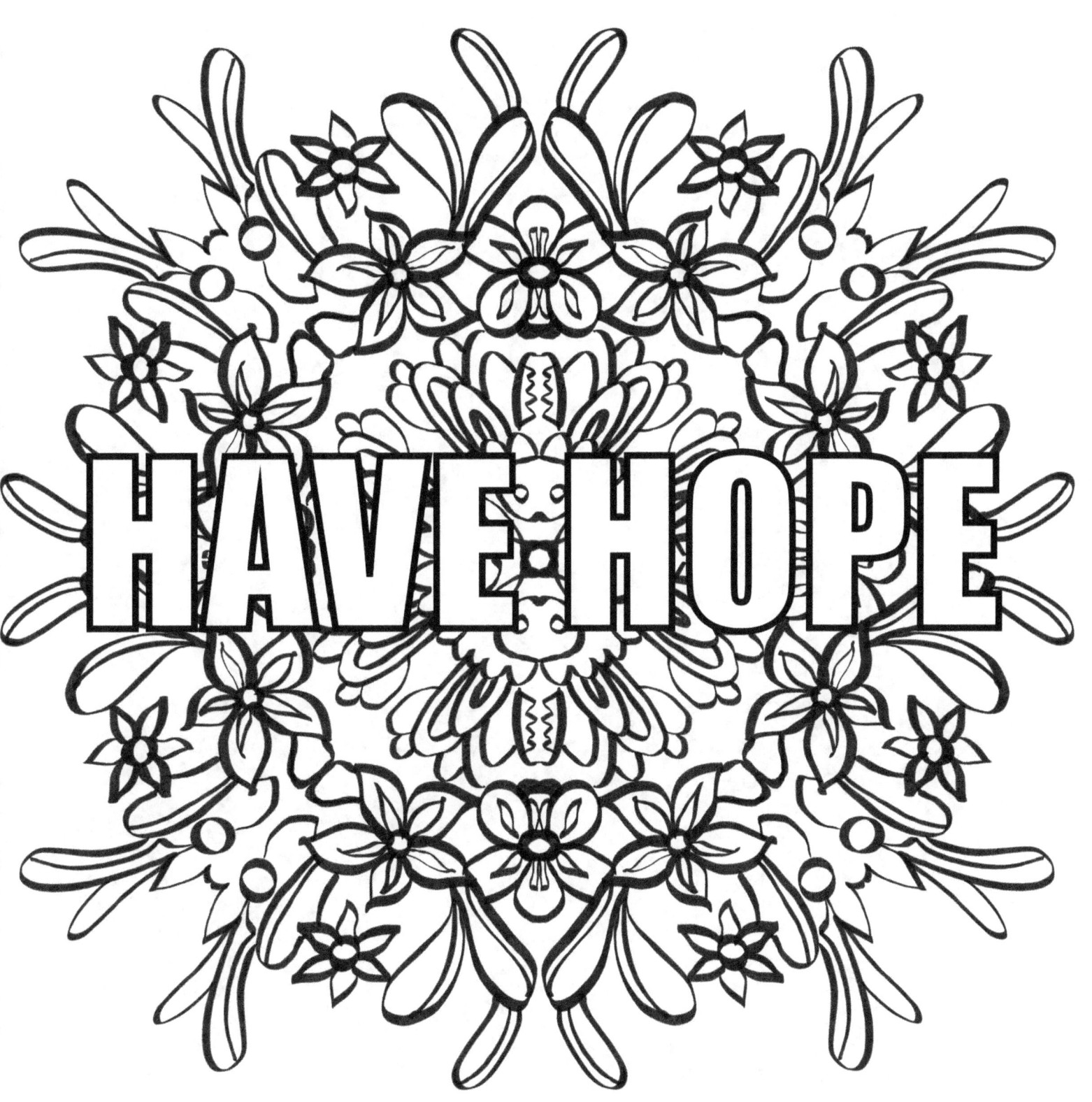

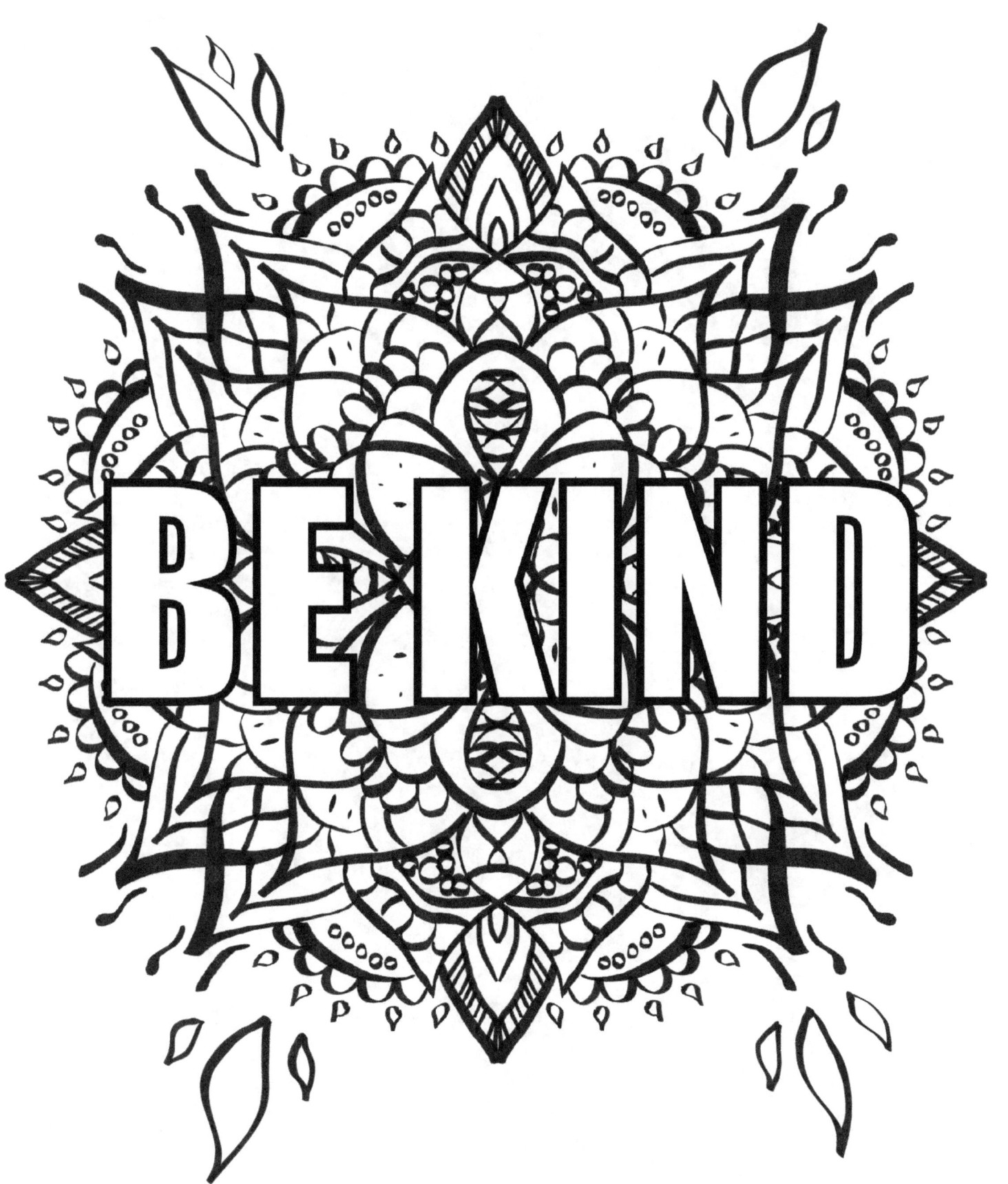